ON ILLUSTRATION

Andrzej Klimowski

On Illustration

OBERON BOOKS

LONDON

First published in 2011 by Oberon Books Ltd

521 Caledonian Road, London N7 9RH

Tel: 020 7607 3637 / Fax: 020 7607 3629

e-mail: info@oberonbooks.com

www.oberonbooks.com

A catalogue record for this book is available from the
British Library.

ISBN: 978-1-84943-112-5

Printed in Great Britain by Antony Rowe Ltd, Chippenham

Contents

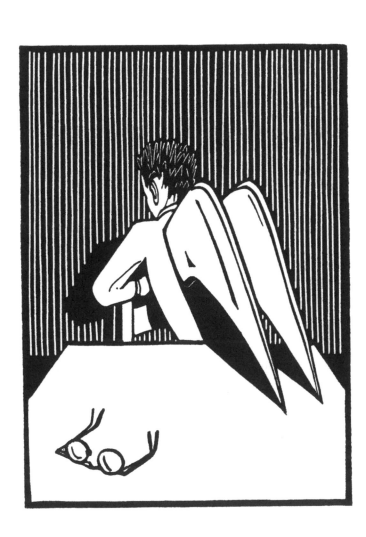

Introduction

These short reflections on illustration will appear fragmented. I have no clear theory or definition of the subject yet I am aware that without it cultural and artistic life would be impoverished. Illustration heightens an artistic experience, both emotionally and intellectually. Often it is our first introduction to culture. It is a form of art that runs closest to everyday life, its presence can be found in the ephemera of the everyday, in newspapers, journals, television, fashion and on the packaging of consumer products.

What follows is an insight into my practice which hopefully helps define the role and status of the illustrator in the creative industries. As a teacher I am often asked to speculate about the future of illustration and of visual communication in general, but I struggle to come up with a clear opinion. I focus on each job as it comes, be it a commission or a self-motivated piece of work. After all, illustration addresses given subject matter, be it literary, journalistic, philosophical or purely commercial. The reader may notice that a few concerns and influences come up more than once during these reflections. Inevitably I

have been affected by my mentors, clients, students and specific works of art.

Illustration lies somewhere between graphic design and painting. Its context is graphic design. An illustrator's work will find its way on to a newspaper page, into a magazine, a book, a poster, on a webpage or a television screen. It will accompany text, illuminate it, comment on it, punctuate or counterpoint it. Its function can be reflective, provocative or decorative. It enlivens visual communication.

What it shares with painting is the desire for self-expression. It expands the imagination. Prior to the nineteenth century painting was illustration. In Europe it served the Church. A largely illiterate society was able to follow the teachings of the Bible through the spoken word augmented by imagery found in churches and cathedrals. Scenes from the Bible were depicted in frescoes, icons, mosaics and stained glass windows. In the baroque period painting became the instrument of the Counter Reformation. The opulent, often ecstatic imagery was a force that endeavoured to hold the Catholic Church together as it underwent a legitimate criticism from Protestantism which in turn placed emphasis on the word. The interiors of Protestant houses of worship were whitewashed; the focus was on the pulpit, not the altar

and ceilings heavily decorated with portentous frescoes and statues.

The emphasis on the visual continued to recede during the Enlightenment. Painting was eventually liberated from its illustrational role through the popularization of print and the invention of photography. Photography was now seen as the most accurate medium for depicting reality. During the Victorian period engravings based on photographic references were the most widely used form of illustration. Popular novels by authors such as Charles Dickens were serialized in weekly magazines; each episode would be accompanied by a large illustration. The golden age of illustration had begun. Artists such as Gustave Doré and Honoré Daumier in France and Aubrey Beardsley in England were celebrated. Their work was closely associated with writers and poets such as Oscar Wilde and Charles Baudelaire. Baudelaire himself held the illustrator in greater esteem than the painter. In his essay *The Painter of Modern Life* he praised the illustrator for being a man of the world, broad-minded and sensitive to the workings of modern life. The artist/painter by contrast, was more limited, tied to his palette and easel, living a secluded, bourgeois existence.

According to Baudelaire, the illustrator was at the centre of contemporary life, recording the behavioural patterns of different social classes, their fashions and gestures, the

elegant boulevards and arcades with their shops and the slums of the poor and underprivileged. Baudelaire focused his attention on an illustrator who he referred to as Monsieur G, a man whose work regularly appeared in the leading Parisian magazines and journals. G did not limit his work to illustrating urban life but depicted military campaigns and the Crimean War for *The Illustrated London News*. Baudelaire admired the humility of this illustrator who rarely signed his work, at best leaving his initials in the corner of some of his compositions.

Even today many illustrators hold on to their anonymity. Often the public are well acquainted with illustrations they see in newspapers, on book covers and posters, but rarely are they able to identify the illustrator. This lies in sharp contrast to the celebrity status of fine artists.

. . .

'Graphic design and illustration are the same as painting.'

. . .

'What interests me is form. Wrestling with form. I am not concerned with defining my profession.'

. . .

'It's important for me to create my own pictorial lexicon, a new grammar. To have my own formal values, my own language, my own voice.'

. . .

'With every new commission comes a new struggle. I wrestle with a problem that has to be worked out according to new criteria. To find an appropriate form for specific subject matter is demanding. With practice much of the work becomes automatic, a reflex action.'

. . .

These thoughts reverberate in my mind; I take them to be my own. In truth they belong to my old professor, Henryk Tomaszewski.

I

Amsterdam

In April 1991 I persuaded *Eye*, the international graphic design magazine, to send me to Amsterdam to cover Henryk Tomaszewski's retrospective exhibition at the Stedelijk Museum. I had not seen my old professor for nearly ten years and was eager to catch up with all the news. After I left Warsaw I corresponded with him and received beautifully illustrated Christmas and Easter cards from him, characterized by his wicked sense of humour. During the period of martial law many of his letters were marked by the censor's thick black lines cancelling out words and even whole sentences. They introduced a certain drama to Henryk's idiosyncratic handwriting.

I arrived at my hotel in the evening and set about formulating questions that I wished to ask him during the interview. That night I slept badly. I heard the roar of wild beasts and the cacophonous songs of exotic birds. At breakfast I told the waitress of my dream. She smiled and told me that my room overlooked the city zoo.

We met up in a café a couple of hours before the opening of the private view. We eyed each other up; I

had lost much of my hair, he was more hunched over. We embraced and started our conversation. I asked him about the poster announcing his show, which was pasted on hoardings and billboards throughout the city. It was eye catching, so different to all the other posters. I pointed out to him that his work stood apart from that of his colleagues. Henryk smiled and, trying to avoid false modesty, nodded his head.

Perhaps the fact that my work is so distinguished, that it "shines" in its disparity is due to having been left behind with my outdated manufacturer's craft.

I have not been affected by new technology. Even if I were to learn to operate the digital programmes I would never be able to create a "new flower", I would not find a new voice, a new tonal range. I am stuck with my paintbrush. Most graphic designers still have their paintbrushes, but they lie hidden in the recesses of their studios. For me they remain key instruments.

'So how did you arrive at the design of your exhibition poster?' I asked him.

I rarely have exhibitions; my work belongs in the streets and the bookshops. But in the late-Sixties I had a retrospective in Switzerland and I designed a poster that,

I think, answered the brief perfectly. Look, the work of an artist, a designer, is a continual struggle with form; the eye and the image. So I painted the profile of a head in grey emphasizing the eye in green outlined in black. The eye was fixated on a patch of red colour hovering before it. I simply portrayed this constant battle between the eye and colour. The rest was simple. Under the profiled head and shoulders I set the information: Henryk Tomaszewski... The name of the museum... The dates, etc, etc.

This was done cleanly with a sans serif font, in order to anchor the freehand illustration above it.

When the museum's curator in Amsterdam asked me for a poster for this show, I panicked. I had no idea what to do. How could I improve on the profile I painted all those years ago? I had already made the perfect exhibition poster. But I said to myself, Henryk, you have to maintain standards; you can't bring shame upon yourself.

I frantically scoured the studio and looking into a plan chest drawer I brought out a drawing, a long forgotten sketch.

Tomaszewski reaches into his pocket for a pencil and on a paper napkin draws the word LOVE in capitals. Next to the L he draws an O; below them he adds a V and

an E. He doesn't write the letters, he draws them. The L is slightly curved at the top; the O resembles an open mouth. On the printed poster it is overlaid by a red circle like lipstick. The V takes the form of the female sex, with dashes of expressive strokes around it suggesting pubic hair, while the E has an extra horizontal stroke, giving the impression that it was painted at great speed.

The immediacy of his drawing is what characterizes his designs and illustrations. Looking at one of his posters one gets the impression that it is being acted out before your eyes: the energy of the drawing process is still evident. To my mind this quality is very hard to pull off successfully. You see it in music or in acting: no two actors will play the same role the same way. One will always seem more genuine, more alive. An illustrator may work out a conceptually sound idea for a picture, just as an actor will study and learn his lines, but when it comes to the execution of the drawing or delivering a speech something may be missing. That *something* is a life force, or what the French call *élan*.

The picture message of LOVE is contained within a sober typographical framework: the artist's name runs across the top of the poster in upper and lower case Baskerville, underneath it in a small point size and ranged left the words: posters, drawings. In the bottom right

corner on a neutral grey panel Tomaszewski includes the name of the museum and the dates of the exhibition.

He sighs with relief and puts down his pencil. 'I managed to pull it off.' Tomaszewski loves, I thought to myself, and my mind went back to how much time and thought he dedicated to us, his students at the Academy.

I asked him about teaching, whether it gave him anything.

'Nothing', was the short answer. 'Getting up in the morning, shaving, travelling across the city, and then having to comment on senseless scribbles the students brought in. Of course it was different when I came across someone who really wanted to learn, someone like Mr Klimowski…'

I stirred in my seat, and we both laughed.

Momentarily I remembered an incident when I asked him for a reference letter to help me become a member of the Polish Artists' Union, a qualification without which I could not practice my profession. I carried the letter to the Ministry of Culture and seeing it was not sealed I took a peak at its contents. One sentence struck me by its coquettish ambiguity. It read: 'teaching Klimowski was almost a pleasure.'

Our coffees arrived and in no time Tomaszewski was drawing on another napkin. A couple of years ago he had a similar experience of receiving a commission which he

found difficult to respond to. To mark the two hundredth anniversary of the French Revolution, the Committee for Human Rights invited leading international designers to submit a design for what was to be a prestigious collection of posters. He was facing a dilemma as to whether he could invent anything original for such a poster. So much had been said and written about the French Revolution; all its noble aims had been fulfilled. Aspirations of Liberty, Equality and Fraternity had to a large extent become a reality, at least in the democratic Western states.

So what could he do to make a poster that was not empty sophistry? How could he make it relevant to today's problems? He had no idea, and reluctantly informed the organizers in Paris that he was unable to respond to the task.

They kept pressing him, extending the deadline for printing his design.

Every epoch has its problems and tragedies. There is always some cross to bear. Ours is the mounting responsibility of caring for our ecosphere; we are slowly killing our planet. This is our cross, thought Tomaszewski. He started to draw me a cross. From either end of a horizontal line taking the form of a pipe or tube, he in turn scribbled smog ascending and sludge descending, leaking out. At the intersection of the horizontal and vertical lines of the cross, red flames symbolized an urgent cry for help.

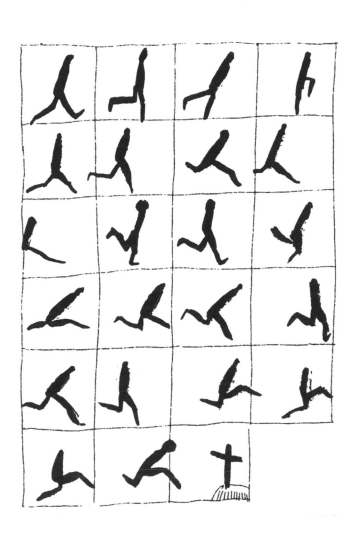

Above the roughly drawn cross the words *Liberté, Egalité, Fraternité* were wedged in-between red and blue slabs, the French national colours. Below that was added: *dans la pure biosphère.*

Henryk Tomaszewski's fiery response to commissions accentuates the need for the graphic artist to make the subject relevant to the times he lives in, and relevant to himself as a thinking individual, otherwise the illustration or design that he creates remains neutral. Interpretation is the key word.

If a client specifically commissions a given illustrator to do a job, it is for his individual ability to interpret a given subject using his range of techniques and graphic approaches; he commissions him for his mind and intelligence. For example, how would you design a theatre poster for a play that is being directed by a director with a very idiosyncratic approach to staging plays, without mimicking his visual language?

In one such poster that Tomaszewski designed, we see an old coal iron on an ironing board bearing the name 'Witkacy'. A metal plate on the iron carries the words 'Teatr Studio' where we might instead have expected to find the manufacturer's name. It is an intriguing arrangement, beautifully drawn, but what does it mean?

'Witkacy' was a nickname used by Stanisław Ignacy Witkiewicz, a famous and controversial Polish dramatist

active in the 1920s and 1930s. Teatr Studio was run by Józef Szajna, a prominent figure in contemporary Polish avant-garde theatre who created dramatic spectacles similar to performance art. Whenever he adapted and staged a play by another writer, little of the original author remained. So by adapting Witkiewicz, Szajna is ironing him out, bending and shaping the writer's work to fit his own vision. It says much for Szajna, though, that it was he who commissioned the poster, while Tomaszewski, without seeing the script or attending rehearsals, knew exactly what to expect and how to interpret it. He was making his own comment, reserving the right to be free in his interpretation.

As we were leaving the café to make it on time for the opening of the exhibition, I glanced back at our table. It was strewn with napkins covered in drawings, Tomaszewski's 'visual thoughts'. At the academy we used to collect his little drawings after critiques and tutorials. I still have them, glued into my notebooks.

2

Brno

International Graphics Biennale 2010
A symposium entitled 'Is The Idea Enough?'

I had to leave the lecture theatre and step out into the street for a breath of fresh air. I was nervous. I crossed the square and entered a small shop. In its dark interior I found Scott drinking coffee from a cardboard cup. 'I could do with one.' 'The machine's behind you,' the American graphic designer replied. 'Just be sure to press the right button.' I leaned over to read the instructions: espresso, no sugar. The thick, dark liquid trickled out from a short nozzle. I raised the small cup to my lips, looking at my friend. The lucky devil had just delivered his lecture; now it was my turn.

The coffee turned out to be sweet. Never mind, I thought, the sugar would give me a rush of energy. Scott Santoro had given a talk that was sincere; in it he mentioned that he came from a family of plumbers. Everyone assumed that he too would become a plumber, but instead he chose graphic design. Nevertheless, plumbing had an influence

on his design and illustration work. Letterforms, collages and page layouts were influenced by the aesthetics of waste pipes, drainpipes, S-bends and gutters. He even carried his designer's materials in a handyman's toolkit when visiting his clients.

Apart from showing slides of his work he also showed the audience a short video that he had shot from the top floor window of his New York studio.

Zooming down on to the street below he captured an incident that was as bizarre as it was unexpected.

A tramp was lying fast asleep on a stand outside a shop. The shopkeeper emerged on to the pavement and began to tug at the tramp's jacket, in order to wake him up and send him on his way. Turning his back, the tramp ignored the man. There was no sound to the video, which made what we saw all the more unsettling. The recalcitrant vagabond had an air of defiance about him akin to Charlie Chaplin's movie persona. Frustrated, the tradesman withdrew into his shop only to reappear armed with a water hose, which he hurriedly connected to a fire hydrant and proceeded to hose down the unsuspecting tramp. The force of the water jet not only unsettled the tramp but collapsed the trade stall from under him. A few pedestrians stopped in their tracks to observe the scene.

I never lecture from notes; fiddling around with reading glasses then taking them off to see the audience,

hinders concentration and is conducive to confusion and panic. My slides guide me through a lecture. Images, after all, constitute my language. I formulate ideas through pictures. I am an illustrator.

I cleared my throat a few times, took a sip of water from a glass perched on the lectern and gazed into the darkness of the auditorium. Once the first slide came up, I felt at ease. The projected image showed a man holding a box-like camera up to his eye. A miniature-winged figure of a naked woman was hovering at his side and whispering into his ear. I painted the picture for myself with no particular motive in mind. I don't know who the man was but the painting could be read as a self-portrait. I had recently completed a novel without words about a pinhole camera and a camera obscura that steal images only for them to reappear in an altered state elsewhere, but I think that the painting was a metaphor for the illustrator.

I see the illustrator as a transmitter, one that receives messages and transforms them into images.

My early work has always relied on photographs and their transformation through graphic means such as collage and photomontage. I have made my own photographs and clashed them with found, archival material, springing a visual surprise on the viewer and encouraging him or her to intellectually or emotionally process the effect and arrive at a possible interpretation.

The magical process involved in the photographic darkroom, augmented by the physical montage of contrasting ingredients, were processes that fascinated me.

With the increasing and almost infinite possibilities of image manipulation offered by digital media, I consciously decided to move away from photography and embrace the limitations of the more traditional techniques of drawing, painting and printmaking. The black and white simplicity of the humble linocut gave me the opportunity to create simple designs that leave much to the imagination. The man in my painting is not holding a real camera but a box. It has no lens; it is not even a pinhole camera because its aperture is a little window. It suggests the camera of my past that is now redundant. I prioritize the imagination over technique.

I changed the slide and continued the lecture.

I've given my talk the title: 'Every work is a new beginning'. It is a magical moment when a germ of an idea is formed. Often it is not a 'grand idea'; it can start with an anecdote, a small incident or feeling. A work can sometimes start without an idea, it can emerge when running through random images or words and making connections between them. Patterns emerge; the artist or designer gives the patterns form, creates structures that invite the spectator or reader to interpret them and give them meaning.

For a long time the 'idea' was the quintessential element in graphic design. The goal of the designer was to find a perfect form for communicating an idea to the public. The most effective form was unambiguous, direct, conveying a message with the simplest of means. Anecdotes and embellishments were superfluous. When we are constantly bombarded by imagery and information, the messages that are conveyed simply and with telegraphic speed stand the best chance of gaining our attention.

Ideas-based design prevailed for several decades but eventually became repetitive, predictable and formulaic. What were once clever visual metaphors had turned into clichés and no longer stimulated the discerning public through their wit and intelligence. As a reaction to these staid formulae, graphic design turned to decoration. Modernist minimalism was replaced by the baroque cocktails of postmodern design. The complex layering of typography and imagery were hard to decipher and interpret, their aesthetics outweighed any message that the design intended to articulate. These designs resembled rococo art, whose forms addressed the senses and left little for the mind.

With the present century, graphic design began to find a new economy of expression, returning to a matter-of-fact functionalism. Perhaps it borrowed something from

the cool aesthetics of conceptual art or reacted against the excessive production values of advertising.

As a practitioner of the graphic arts, where do I stand in all the back and forth of prevalent trends and philosophies?

For many years I have never asked myself this question. All my energy was absorbed in the production of works. I designed posters, books, short films and made illustrations for magazines and newspapers, with occasional work on advertising campaigns. But my involvement in teaching has grown progressively over the years and I have felt obliged to engage with some of the debates in art and design. Within an art educational context my philosophy is simple. It is to extract from students their true individuality, so that they can identify their own artistic temperament and understand the contexts within which their art grows and develops. Another ability that I hope the students will attain is an objective distance between themselves and their work. To see their own work through fresh eyes, as if it was made by someone else. Only then can any shortcomings or faults be identified. This is most difficult to accomplish, but vital to the practicing artist/designer. In order to help them achieve these skills I try to design challenging projects. Over the last ten years I have built up a project entitled The Visual Editor; it deals with narrative, and mainly pictorial narrative.

I think that it is narrative that has always been at the core of all my artistic activity. In the early years I was unaware of this. I studied sculpture and painting and was left to my own devices. It was a lonely activity and I was aware that I had few stories to tell with my limited experience of life. All around me my colleagues were creating abstract art, freestanding sculptures, installations and conceptual drawings accompanied by cryptic texts. How was I to find my own voice? Where could I look to for inspiration?

Together with two other painting students, I started a college film club. We showed films and I designed posters for the screenings using lithography and screen-printing facilities. This activity led to me working with photography, photomontage and collage. I developed an interest in typography. By the time I graduated in painting from Saint Martins School of Art I decided to work within the graphic arts and applied to study poster design with professor Henryk Tomaszewski at the Warsaw Academy of Fine Arts.

The kind of graphic design that I was interested in could only have come from Poland, where the emphasis was on an individualistic interpretation of subject matter, a painterly approach to composition and the playful engagement with building new forms. The subjects that the professor set us were difficult and demanding.

Students were required to stretch their minds by finding a visual form to depict a philosophical or literary concept.

Tomaszewski often looked to aphorisms for his subject matter: 'in unity there is strength', or how can you depict the idea of 'a big nothing' and a 'small nothing' in poster form? We laboured for weeks, producing dozens of sketches and drawings before reaching a solution that the professor would approve of and allow us to develop into a full-sized poster. After one year of working a student would not have produced more than four posters. We would construct the designs from individually painted fragments, which allowed for flexibility when altering the compositions in order to effectively convey the subject matter. Even if the final poster was a painting or made photographically, it was arrived at through montage, through careful editing and juxtaposition of image and text.

After studying I found myself designing posters, book covers and books. When designing a poster, I would hint at a film's or a play's content rather than illustrate it, using metaphors and symbols. I was working within a well-developed tradition, free from any advertising constraints. A film or theatre poster was meant to inform the public of a cultural event and not sell a product. People flocked to the cinemas irrespective of the posters; they were appreciated for their enhancement of an artistic or cultural experience. In Warsaw the public could vote for their favourite

poster of the month through their local newspaper, *Życie Warszawy*. Many enthusiasts collected posters. Museums had comprehensive collections that were often shown in thematic exhibitions; the Poster Museum in Wilanów held the International Poster Biennale.

When I returned to the UK in the 1980s I had to find a new outlet for my design and illustration as posters were rarely commissioned from graphic artists; there was no tradition in this field. I focused on book covers and newspaper illustrations. The publishers Faber&Faber had undergone a redesign by John McConnell of Pentagram who had the intelligent concept of pairing illustrators with authors. It was like casting the right actor for a specific role. I made covers for Mario Vargas Llosa, Rachel Ingalls, Kazuo Ishiguro and Harold Pinter, but my covers for Milan Kundera's books attracted the most attention and acclaim, gaining me many new commissions.

Every profession has its ups and downs; fashions change, as do art directors. In the mid-Nineties I found I was getting fewer commissions. This made me fall back on my own experimental work, work that I had done for myself over the years. My professor, Henryk Tomaszewski, used to refer to this kind of work as 'professional hygiene'; experimentation for its own sake. This playing with form and indulging in one's own obsessions was vital to keep

work fresh and lively. Sooner or later the experimentations would find their way into commissioned work.

I designed a logo for The International Literary Festival in London. It depicted a flying man with outstretched arms. On his shoulders, instead of wings, there was an open book. The festival never happened due to lack of sponsorship, but my flying man began to live a life of his own. I made a series of linocut prints based on his imagined adventures and soon realized that somewhere within these compositions a story was gestating. I decided to work quickly and intuitively. Abandoning the linocut, I worked directly with a brush and ink, paying little heed to technique, allowing the story to flow. I moved from one image to the next, never looking back, no analysis or reflection. It was the first time that I had worked in a stream of consciousness. It was exciting, I was constantly surprising myself. The book was published by Faber under the tile *The Depository: A Dream Book*.

I made more books for Faber, each one different. The second, which included collage as well as drawing, referred to the different levels of reality in the story. By the time I embarked on the third, I took pity on the reader and included text as well as images. I am still surprised how difficult people find it to read a book comprised solely of pictures. Such a book leaves its readers with a lot to do; they have to make their own connections and associations

to allow them to form a narrative. On re-reading they may come up with new interpretations.

When talking with audiences at readings and lectures, I am often surprised by their take on my stories. It pleases me just how imaginative the public can be.

From illustrating or 'signaling' other people's stories I have moved to writing and illustrating my own. This now occupies most of my time; even my work with students revolves around the production of self-authored books.

There is a huge appetite for stories, a need for narrative and, in the words of the avant-garde artists Stefan and Franciszka Themerson, we need to produce not bestsellers but best lookers. Every new book needs its own original form. That can happen when every work is truly a new beginning.

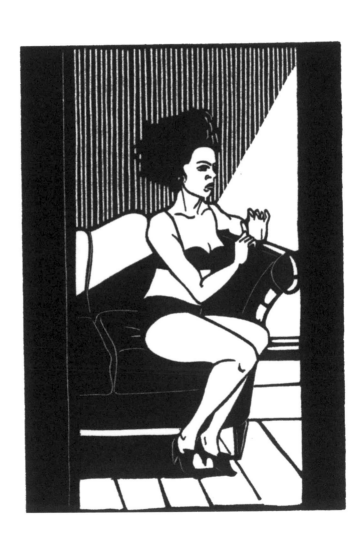

3

Birmingham

Some time ago I was asked to review an exhibition for BBC Radio 3's *Night Waves*. Two Soviet illustrators were showing their work at the Ikon Gallery in Birmingham. One of the artists, Ilya Kabakov, was to be at the gallery putting the final touches to his installation before the opening. I had the opportunity to conduct an interview with him, enabling me to quote him for the live broadcast in London that evening. Kabakov, together with his wife and collaborator Emilia, gave me an insight into their working methods. There was no doubt in my mind that I was talking with artists who had a clear idea of what their art was about and how it should be disseminated to a discerning public. They operated in a global market. Kabakov told me that illustration had been a way of making a living when he was still resident in Moscow. He took on illustration commissions in order to finance his art projects. Together with his wife, he was part of the unofficial art scene in the former Soviet Union where artists could only show work and exhibit in their overcrowded apartments. Samizdat publications and

underground promotional graphics were used to promote the work, which eventually caught the eye of Western art critics, gallery owners and curators.

For a long time Kabakov's installations existed only as illustrations. Pencil drawings and watercolours of labyrinths, corridors and enclosures conveyed the absurdities of everyday life in the Soviet Union. Many of his pictures ridiculed the bombastic nature of Soviet propaganda art. The world of bureaucracy was exposed as a redundant archive or reading room whose inhabitants were drowning in a sea of paper.

The Kabakovs left their country for the United States where they were able to realize their ambitious projects creating installations in major museums and international art biennales. Ilya Kabakov never again had to undertake commercial illustration commissions; however his own conceptual illustrations continue to augment the installations for which he is renowned.

. . .

Drawing is perhaps the most immediate medium through which an idea can be articulated. Illustration takes drawing into the narrative realm.

A group of young architects working in the Soviet Union in the 1970s and 1980s found it hard to have any

of their designs realized and never saw anything built. Their visions did not conform to the official architecture endorsed by the state and existed solely on paper. They were referred to as the 'paper architects'.

Alexander Brodsky and Ilya Utkin stood out from the group. Steeped in monumental neo-classicism as exemplified by the somewhat eccentric visionaries Ledoux, Boullée and Lequeu, they began to weave improbable narratives into imaginary spaces that were both utopian and impractical.

Following the tradition of Piranesi, the architectural duo made portfolios of etchings. Houses made of glass, towers emerging from artificial lakes, underground villas, plinths and columns supporting teratological figures, transportable theatres, were all beautifully designed with a graphic sensibility and an eye for detail. Frustrated by not being able to design real buildings, Brodsky and Utkin submitted their etchings to various architectural competitions. They caught the attention of architectural journals and publications and soon garnered international prizes and awards.

Exhibitions followed: they became popular in Japan and the United States. Installations and pavilions were commissioned.

. . .

An artist is never unemployed. He or she may have no gallery or no agent to represent them. There may be few or no commissions, yet artists can produce, make pictures for themselves. This is particularly true of the illustrator. A painter needs a studio to work in; for an illustrator a small room can suffice. The drawings may go into a drawer but sooner or later they will emerge. There are many such artists around whose technical requirements are modest: pencils, pens, ink, watercolours, scissors, paper and nowadays, more often than not, a laptop computer.

As I see it, there are few art directors or editors who would stick out their necks and commission something original, something different. Many developments in the arts go in waves. A period of innovation and inventiveness is followed by stagnation that is often brought about by playing it safe, when well-tried formulae are repeated *ad infinitum* in the quest for guaranteed success.

I have worked for publishers that are independent. They publish high-quality literature and have an appreciation for the aesthetic qualities of a book. Just as in opera the overture sets the mood for the awaited spectacle before the curtain goes up, so the cover of a novel, a play or a collection of poetry sets a specific tone. The potential reader receives the first signal of what the volume may contain. An attractive illustration will catch the eye. It can flirt with the punter, provoke, intrigue or seduce him.

An independent publisher can establish an identity through the covers of its books. If the covers are different, more alluring than the ones of competing imprints, then they will etch their presence on the minds of the public. Given the continual pressure to maintain sales in a competitive market, publishers have to reinvent their look. When I was working for Faber&Faber you could easily recognize an author by the cover of his or her book. An illustrator was matched with an author; an immediate identity was established. This has since changed; I can no longer tell if a book is authored by Paul Auster or Hanif Kureshi by looking at the image on the cover. Even if the cover is typographical, then the letter forms whether typeset or drawn freehand should tell the reader something about its author.

The advantage that an independent publisher has over a corporate one is that it does not have to make decisions by a large committee. If it associates itself with intelligent and imaginative graphic designers and illustrators, it can have an authoritative visual presence and an aesthetic that can continually develop and surprise the viewer. It is discouraging when these smaller establishments begin to feel the pressure to follow the trends set by the corporate publishers whose formulae are thought to enhance sales figures. Perhaps it can be compared to the pressure Hollywood exerts on independent production companies.

I am making these observations because I am conscious of the shrinking market for illustration and, like Brodsky and Utkin, I am sporadically forced to withdraw into making work that is destined for my plan chest drawer. I spend half my time teaching working with illustration students who are talented and imaginative individuals. Together with my fellow tutors I prepare students to be proficient in a discipline that is precarious. My professor declared that he taught students how to think. I uphold this ambition. Only last week many of our students were out on the streets of London protesting against drastic cuts to higher education funding for the humanities. The arts and humanities are seen to be a luxury and not contributing significantly to the economy. We teach the students how to think and they in turn, whether they have studied history, philosophy or art and design, go on to contribute ideas that have the potential to change the world for the better.

· · ·

Most people are aware of how much work goes into writing a novel. The writer is seen clocking in the hours, thumping out thousands of words every day on a keyboard. There is all the research to be made; the author investigates his subject from all possible angles: historical,

social, political, psychological, topological, etc. All this is followed by many rewrites; many drafts are made before the chronology, dramatic build-up and rhythm are seen to work and the book ready to go to print and transport the reader into a new reality.

The same is true of music. Anyone who has taken piano lessons will be able to appreciate the complexities of composition and interpretation. Only continual practice will enable a musician to render a piece of music beautiful and expressive, hitting the emotions in a spirit envisioned by the composer. The public is also appreciative of the painter or sculptor who struggle with materials that are often difficult to control when shaping a new form, one that strikes us by its originality.

Is it the same with illustration? Perhaps not, because by its nature illustration has a short life, an ephemeral existence. It is subservient to a pre-existing subject, which is often literary. An illustration accompanies another form: the written article, a book, a play, film or piece of advertising. The time within which an illustrator is given to respond to a message or subject is short. It's dramatically referred to as a deadline.

Yet the speedy response to interpreting a subject is part of the quality and value of a good illustration. It should look spontaneous, fresh and vital. This is where its vibrancy and intelligence lies. And this, perhaps, is

what the audience does not see nor fully appreciate. They may think that the illustrator's dexterity is a preordained talent. This is a misunderstanding. Spontaneity, dexterity and intelligence come with practice, just like the musician continually playing and practicing on his instrument. The musician also needs a good composer and an illustrator's art can only flourish when there is an intelligent and visionary client.

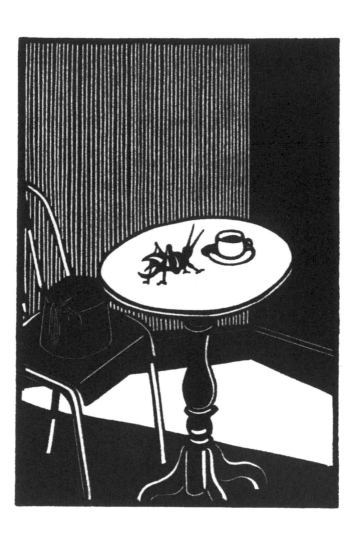

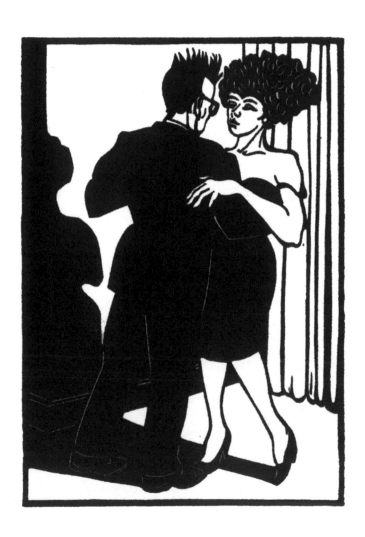

4

Moscow

Moscow is a huge city. The hotel we were booked into was huge. Modern, monumental and dark, it brought back memories of communist grandeur. The taxi driver had to take our passports and show them to a security guard at a checkpoint before we were waved through to the hotel grounds. The place seemed empty. It continued to remain empty throughout most of our stay; only on the final two days an invasion of Chinese businessmen filled the reception hall, the bar and, in the mornings, the breakfast room. The window in my room opened out on to the river, a broad vista that encompassed two palaces of culture, the golden onion domes of orthodox churches and on the river itself, a gigantic statue of Peter the Great. Pompous and ostentatious, it was an eyesore.

Initially I was surprised to have been invited to talk about book illustration and design at Moscow's International Book Festival, as I've always thought of Russia as the place of great innovation in book design as exemplified by the Russian Constructivists in the early part of the twentieth century. Few designers could equal the bold approach of El

Lissitzky or Aleksandr Rodchenko. As I explored the city I soon realized that the legacy of these legendary designers was hard to find. The bookshops were ugly; I could not identify a single attractive book cover. I was part of a group of speakers selected by the British Council to lecture and run workshops at the festival. Between us we were able to cover the digital future of the book, storytelling, novel writing and book cover design and illustration.

The festival took place not far from our hotel in a vast modern, Sixties building that was showing signs of deterioration. It was situated in a park full of statues of Soviet heroes who had fallen from grace. Doug Wallace and I were to speak in one of the marquees set up in a courtyard that divided the main building. Doug is the marketing director of Self Made Hero, an ambitious newcomer in graphic novel publication. It was evident that the Russian public were curious and keen to learn as much as they could about the British book industry; our venue filled up quickly but before we began our presentation, a small bird flew into the tent above the heads of the dismayed audience. It was a good omen because our talk went well.

As we spoke, I began to appreciate fully just how important a role a book cover plays in the promotion of a book and its placing in the market place. I concerned myself with aesthetics and the cultural role of design and Doug emphasized how these concerns have a positive

impact on marketing. I began with the one-off title, the book that did not belong to a series and merited a unique design approach to its cover. I showed a slide of a cover that I had had trouble with making. The initial concept was clever, the image dramatic, however its overall effect was somehow predictable. It did not surprise. In my frustration I brushed the artwork from my drawing board and was shocked to find that when I was looking at it upside down on the studio floor it appeared stunning. The theme of the simple graphic intervention came up more than once throughout the talk. Perhaps this was the reason why I found working with collage or photomontage so rewarding. It provided me with a method for speedily generating unexpected associations and dramatic clashes that took the eye by surprise, accelerating the mind in its search for meaning and significance. My working method was similar to the one I employed when designing posters, although the change of scale was significant. A poster image would often verge on the melodramatic at the risk of being crass. Posters are loud, they have to work from a distance, they go for a knockout effect.

Book covers also compete for the eye's attention but once they have succeeded in doing so they take on an intimate role. A book is handled by the reader, scrutinized at close quarters. Once it's in the reader's possession it becomes a prized object and when it is read the cover prolongs the

reader's intellectual and emotional engagement with the text.

Illustrators are usually well read individuals. The illustrator's images are rich in narrative associations; they are often motivated and inspired by literature. It is not surprising therefore how important a role illustrators played in the design of book covers for Faber&Faber during the 1980s and 1990s. The illustrators never gave away the plot of the novels but focused on generating appropriate atmospheres, thus enhancing the readers' sense of discovery.

By isolating the book's typographic information within a panel discretely placed in the upper left-hand corner of the cover, McConnell gave his illustrators maximum freedom to create adventurous compositions. Usually the title panel was reversed out with white type on a black background unless the colours within the illustration merited a different panel colour: red, orange, green or a neutral white. Once the illustrator was cast to accompany an author, the public could easily identify the type of book they were looking at. Empathy between author and illustrator would develop. It was easy for me to work on book covers for Mario Vargas Llosa's fiction, as I had long been an enthusiast of Latin American magic realism. The same was true when illustrating the covers of Rachel Ingall's short stories. Their unusual twists

and turns and unexpected endings were a challenge to signal in visual terms without giving too much away. I particularly remember a story entitled 'The Archaeologist's Daughter' from the collection *Black Diamond*. It portrays the uncomfortable relationship between a mother and a daughter who both shared each other's traits. I took a photograph of my wife looking over her naked shoulder about to meet our gaze. I montaged my daughter's face into her mother's face, generating a disturbing tension that was not explicit but enough to establish a train of thought and stir our curiosity. Using my family as models gives the covers a dormant autobiographical ingredient, subtly tracing my own development as an artist as well as shaping the identity of the publisher.

When Faber bought the Harold Pinter backlist from Methuen, his editor shortlisted a few illustrators and presented samples of their work to the playwright for him to choose from. He chose me; we met and discussed an approach. From the clues he offered me I formed a clear idea of how I would work. The covers were going to be understated and drained of colour. I had some twenty titles to illustrate. On our second meeting I drew the author's portrait and gained an insight into the workings of his mind. We became friends even though we rarely saw each other. He left me messages on the answer phone. 'Andrzej, perfect!' Or 'Andrzej, it's fine, but the hand

entering the picture from the left is superfluous.' The covers worked individually as well as in a series. It made me think how important the casting of an author with the right illustrator really is. In this case the editor, Robert McCrum, had done his job well.

Another reason why the collaboration with Pinter was a success was that I had started working for Oberon Books, a small publisher who published nothing but drama and theatre-related texts. Every other week I was reading a play text with the view of designing a cover for it. Initially I worked both on the designs and illustrations but as the publishing house expanded it became clear to me that I should work with a designer and focus my attention on the illustration. By now Oberon had several series to promote. We had to distinguish each series as well as link them to each other as a package. My colleague from the RCA, Richard Doust, and I came up with a simple solution. I would create a black and white linocut illustration, the title would go above it, a thin red stripe bearing the publisher's name and the series 'Modern Playwrights' would run along the bottom. A grey stripe was to be used for the 'Classics' series. Oberon then brought out 'Absolute Classics' for which we designed a distinctive look that stylistically echoed the main series. To refresh the series a few years later I worked with the designer Jeff Willis, also a colleague from

the RCA. Given the growing number of titles published, we had to find a method that would allow for a faster response. In place of the work-intensive linocut I resorted to drawing with brush and ink. These images would float in the space composed by my designer to the right of a vertical colour stripe running off from the spine.

Oberon continued to expand, and to commission a new illustration for every title proved to be uneconomical. Jeff and I came up with a series of generic covers that were abstract and decorative but retained an element of drama. Different genres were matched with different colour compositions, giving the reader some idea as to the type of play they might be reading. In this way four abstract covers could encompass all the titles. Occasionally a very important new title would merit its own illustrated cover, with a distinct interpretation. More recently the publisher was obliged to utilize images, usually production photographs, directly supplied by the theatres premiering the published plays. In this way the covers related to the theatres' own publicity. There was a good commercial justification for this but the designer and I were excluded from the equation.

Oberon Books continues to promote illustration by sponsoring an annual illustration prize at the Royal College of Art and by publishing books such as the one you are now reading. Literature draws us to

each other, as does our love for ink on paper. Now that we are crossing the threshold into the digital realm, it is interesting to speculate how this will affect illustration. I have no idea, but as I was showing my slides to the attentive Russian audience, I knew that in the adjacent tent another member of the British Council team was demonstrating the workings of the iPad.

I continued talking about illustrating covers for books that are part of a series and showed the audience something more unusual. Unusual in the sense that it was different to the work I had been showing up until then.

I had been asked to recommend an illustrator who could generate a distinctive look for a renowned author's entire *oeuvre*. The author in question was P.G. Wodehouse. The series would span more than eighty titles. A wonderful commission, and without hesitation I recommended myself for the project even though everything I had done up until then gave no indication of my suitability. My illustrations were usually dramatic, dark and mysterious. Wodehouse's stories were gregarious, witty, playful and light.

I needed work, income is always an issue, but at the back of my mind I knew that here was an opportunity to reinvent myself. I read the first four titles and realized that they all resembled each other. There was no great theme, no philosophy or drama. On the contrary, it was frothy and effervescent. 'This

is not my cup of tea,' I thought to myself. Yet the texts engaged and entertained me. The language was so playful, the scenes ridiculously artificial. Wodehouse was quintessentially English: eccentric, sober, witty and self-mocking. I had to rise to the occasion and make a fist of it. As I worked towards a concept, I realized how liberated I felt by not having to come up with a thoughtful metaphor or a dramatic symbol. There were plenty of scenes in each story from which to choose to make a relevant image, announcing the spirit of the book.

I decided to combine linocut and gouache paint. The covers would be colourful. A wide stripe across the top third of the dust jacket would contain the title and name of the author. The process was complex and labour intensive. First of all I would make a series of pencil sketches from which I would choose a suitable image. I would work on the selected drawing, eventually transcribing it into a linocut from which I would make a black and white proof print. I would then photocopy the print on to a selection of coloured papers and montage these into a full-colour composition, rendering the backgrounds and accentuating the details in gouache.

The publisher, Everyman Library, approved the ideas and then ensured that the production values matched the ambition of the project. The edition was printed on

acid-free paper and set in Caslon, a typeface designed and engraved by William Caslon of William Caslon & Son, Letter-Founders in London, around 1740. The typographic treatment of the cover was designed by Peter Willberg, a graduate of the RCA. The title was set in a font Willberg designed especially for the series, reflecting a 1920s style so closely associated with Wodehouse. The designer also originated the elegant end papers and decided to reproduce a miniature version of my black and white linocut illustration facing the title page. To date, seventy covers have appeared and during that time I have only had to make two minor alterations, both suggested by anonymous Wodehouse enthusiasts. I had to remove a monocle from Bertie Wooster; apparently he never wore one. A golfing character was also deemed to be right-handed and not a left-hander as portrayed on my cover. I myself have become a Wodehouse enthusiast but still have to be careful not to confuse the characters, given that they all seem to resemble each other.

I concluded my lecture by addressing the subject of the graphic novel, a genre that has preoccupied me these last few years. I have created three of my own stories and have adapted two works of classic literature with the artist, Danusia Schejbal.

I showed slides of illustrations from my novel *Horace Dorlan*, depicting a middle-aged man following an

unusually tall and slender woman down an elegant London street. She looked a little like an insect. As the man caught up with her she abruptly turned and walked up a few steps into a building. On one of the pillars framing the front door a plaque bore the words: Institute of Entomology. As I was guiding the audience through the narrative, someone posed the question: 'Where do your ideas come from?'

'Well,' I replied, 'I was once walking down Queen's Gate in Kensington when I noticed an unusually tall and slender young woman walking a few yards ahead of me. Her sprightly bobbing ponytails could be mistaken for antennae and I could imagine translucent wings unfolding from her rucksack. I quickened my step but before I could draw level to her, she turned and climbed a few steps entering a building. There was a sign outside the door. It read: The London Institute of Entomology.' Sometimes life comes up with a ready-made scenario; the imagination fills in the rest.

5

London

The door of the computer room opened on to the corridor. A tall and slender young woman stood at its threshold, hesitating to move forward for fear of blocking my way. I was taken aback for I did not know this person. Her hair stood wildly around her head as if charged by an electric current. I soon realized that it was Zoë Taylor, one of my students. Initially I failed to recognize her because I had never seen her wearing such contemporary clothing: long loose trousers, a light blouse and high heels. I was used to seeing her in clothes that belonged to another time, the 1950s perhaps. I've often thought that she would be more at home on a *film noir* set than at the Royal College of Art in the early twenty-first century.

Zoë's work has always been exploratory. It reflects her personality. Partly timeless, partly *film noir*, it is charged with a drama that is at once mysterious and melancholy. When I became her tutor I knew I was working with a kindred spirit. Here was a student who wanted to learn, who yearned to expand her visual vocabulary and investigate the possibilities of visual narrative. The projects

I set my students were deceptively simple. I would offer them an ingredient or two around which they could build an image-driven story. In Zoë's case it was a group portrait of minor royals and their entourage of servants. The large picture was painted by Goya who himself appears in the foreground crouching at his easel. The light comes from a solitary candle on a small table at the centre of the composition. At the table sits an old aristocrat, his profile echoed by that of his young son standing at his side. Next to them, facing us, is the aristocrat's young wife whose long black hair is attended to by a hairdresser. Around them are two more children, young girls with their nannies, as well as a few more characters that appear strange, somewhat out of place. A young man with a bandaged head is looking directly at us, smiling. An older man is lurking behind his shoulder, giving the impression that he would be much happier elsewhere. His face is pale, grey and emaciated.

One could read a lot into this picture; several threads could be developed. Zoë, after many false starts, decided to focus on the young woman and the hairdresser. I think that hair plays an important role in her work. The portraits that she draws place great emphasis on hair and hairstyles. Her enigmatic, elegantly coiffured heroines hold something back from us; they are detached like many of the leading ladies in the American films of the Forties and Fifties.

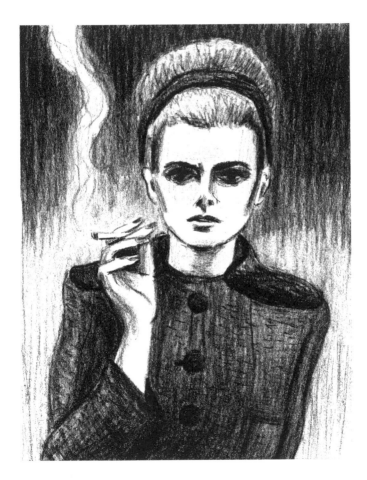

The Blue Hotel, a modest book of thirty-six pages, transports us to a motorway at night. A young woman pulls into a hotel off the motorway. She picks up her room key in reception, enters her room, takes a shower and lights a cigarette. She then does something unusual. She phones for a hairdresser, who promptly arrives with his equipment and savages the woman's magnificent hair, leaving her with a modest bob. He himself has a hairstyle that is not dissimilar to David Lynch's *Eraserhead*. On finishing his work he leaves the room. The woman remains still in front of the mirror, which cracks. Soon she is back on the road. We see her face in the rear mirror of her car.

Now what kind of story is that? It is a short story, a story without words, an illustrator's poem. There is a mystery at the heart of the story, a small twist, and a magic moment. The small books that my students produce are exercises. Many musical composers write small pieces that they call *études*, studies. These are intended to be exercises for instrumentalists, but in most cases they have their own intrinsic artistic value. The same is true with the students' illustrated books. There are no commercial outlets for small picture books, but many of our graduates attract clients who use their illustrators' narrative talents in different contexts. Some get their own regular columns in newspapers, commenting on news events or more often illustrating feature articles on the arts and cultural

life. Zoë's degree show attracted the attention of a fashion designer. Her fashion drawings feature in magazines and on websites. They depict the latest fashions, but her somnambulistic models wander through her invented interiors that are half real, half dreamscapes.

Just as my professor taught me to reduce the design of a poster to an essential visual message, stripping it of all irrelevant embellishments, I have encouraged Zoë to focus on what moves her stories forward; anything that hinders their flow should be eliminated.

Illustrations have a short life, they are ephemeral. Newspapers and magazines eventually end up in the bin, posters are pasted over and digital images flicker on the screens of TV monitors and computers for a limited time. Some survive and find a place in museums or private collections but their job is done when they initially appear in the media. They do however reveal a great deal about the culture of their time, they have an historical value. That is what attracted Baudelaire to illustration. Not only do they give us a better understanding of the customs and aspirations of our times, but also illustration makes life more bearable. In Umberto Eco's most recent novel, *The Mysterious Flame of Queen Loana*, the main protagonist suffers from amnesia after an accident. His memory returns to him through illustration. He is only able to piece together his past by looking through his grandfather's

library collection that now finds itself in an old, dusty attic. Memories are rekindled as he studies old comic books, magazines and children's picture books. The illustrations that we see as children stay with us forever, they play a seminal role in the development of our imaginations; but that subject deserves a separate book of its own.